How to Draw Cartoon Birds

Curt Visca and Kelley Visca

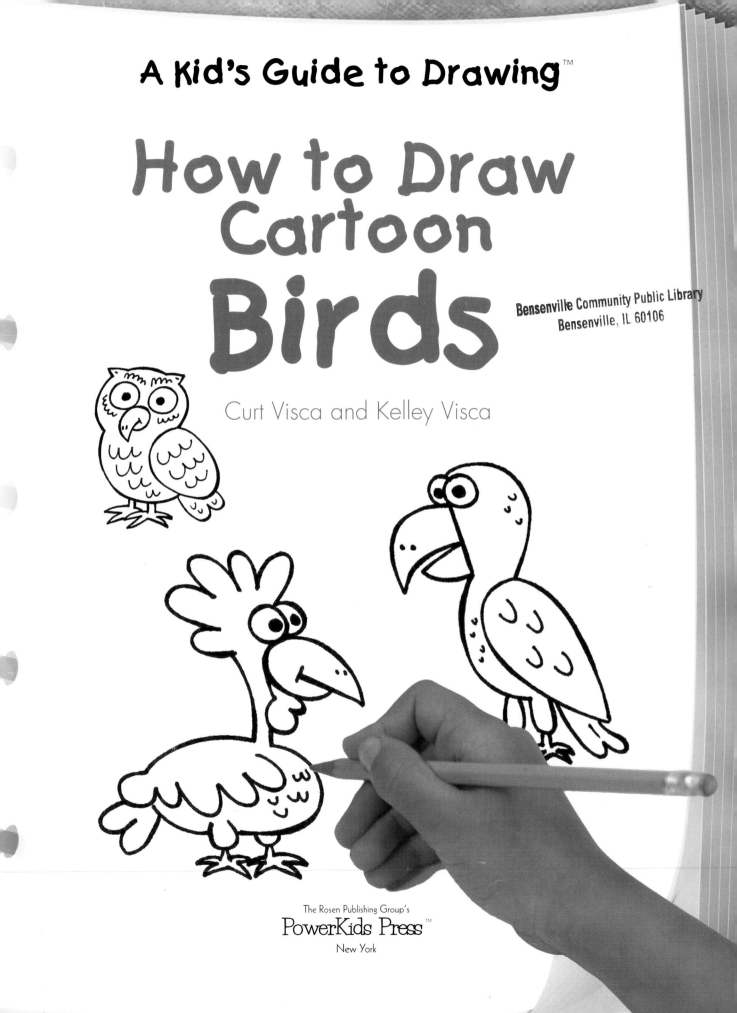

The Rosen Publishing Group's
PowerKids Press™
New York

Dedicated to Curt's mom, Ellen Visca, because of her love for birds

Published in 2003 by The Rosen Publishing Group, Inc.
29 East 21st Street, New York, NY 10010

First Edition

Editor: Natashya Wilson
Book Design: Kim Sonsky
Layout: Emily Muschinske

Illustration Credits: All illustrations © Curt Visca
Photo Credits: Cover photo (peacock) © CORBIS; cover photo and title page (hand) © Arlan Dean; pp. 6, 12 © SuperStock; p. 8 © CORBIS; p. 10 © Uwe Walz/CORBIS; p. 14 © W. Wayne Lockwood, M.D./CORBIS; p. 16 © Pat Jerrold; Papilio/CORBIS; p. 18 © CORBIS; p. 20 © Kevin Schafer/CORBIS.

Visca, Kelley.
How to draw cartoon birds / Kelley Visca, Curt Visca.
 p. cm. — (A kid's guide to drawing)
Includes bibliographical references and index.
Summary: Provides step-by-step instructions for drawing cartoon birds, including toucans and parrots.
 ISBN 0-8239-6156-7
1. Cartooning—Technique—Juvenile literature. 2. Birds in art—Juvenile literature. [1. Birds in art. 2. Cartooning—Technique. 3. Drawing—Technique.] I. Visca, Curt. II. Title. III. Series.
 NC1764.8.B57 V58 2003
 741.5—dc21

 2001003135

Manufactured in the United States of America

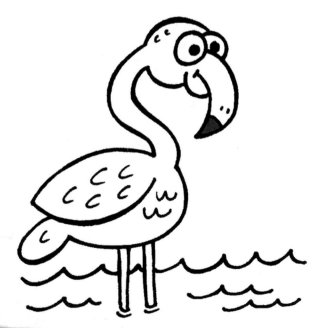

CONTENTS

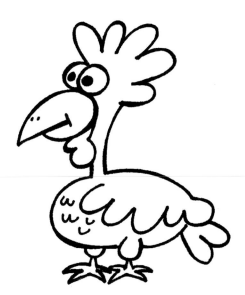

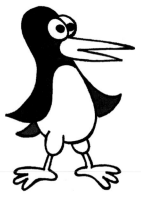

Cartoon Birds

Birds are the only animals that have feathers. These feathers help most birds to fly and also to keep warm. Some feathers are very bright and colorful. Other feathers blend in with the birds' **environments** to provide **camouflage** so that the birds can hide from **predators** that want to eat them. Even though all birds have wings, some birds, like the penguin, are **flightless**. Birds also have very strong beaks, or bills. Birds hatch from eggs and live in many different places, including the desert, the **tundra**, the mountains, and the **tropics**. Some birds, such as the parrot, also make great pets. In this book, you will learn interesting facts about eight different birds and how to draw a cartoon of each bird.

Cartoons are simple drawings that include only the most important lines and shapes. The cartoons that you see in the newspaper can be funny, like the ones in the comics section. There are also **editorial** cartoons, which are about real people and events. When you draw your cartoons, don't worry if your drawings don't look exactly like the ones in this book. Every cartoonist has a different style of

drawing. Your style will make your cartoons look different and special, just like you!

You will need the following supplies to draw cartoon birds:

- Paper
- A sharp pencil or a felt-tipped marker
- An eraser
- Colored pencils or crayons to add color

Make sure you have a quiet, well-lit space where you feel comfortable to draw your cartoons. A desk or a table works best.

Each cartoon begins with the bird's eyes, followed by its beak. Directions under each drawing will help you add the new parts of the bird. By working step by step, by doing your best, and by practicing your cartoons over and over again, you will become a terrific cartoonist.

Turn the page and get ready to draw cartoon birds!

The Parrot

Parrots are colorful birds that live mostly in warm areas around the world. Their feathers are usually green, but some parrots also have blue, yellow, or red feathers. Parrots have

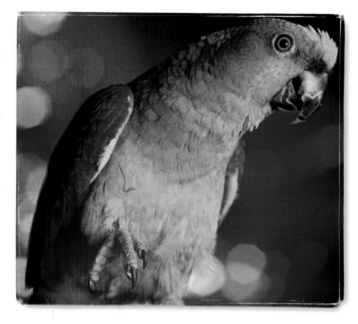

thick, hooked beaks that help them to crack nuts and seeds and to eat fruit. They have **zygodactyl toes**, which means two of their toes point forward and two point backward. These toes help parrots hold on to tree branches and hang upside down.

African gray parrots are very intelligent. They can learn to say up to 800 words, the same number of words a three-year-old child uses. Long ago, parrots were sometimes given as gifts to kings and queens. After his voyage to the **New World** in 1492, Christopher Columbus returned to Spain with a pair of Cuban Amazon parrots for Queen Isabella.

1

Begin by drawing a circle and a curved line on its right side for the eyes. Draw a small circle in each eye for the pupils and shade in these circles.

2

Next draw two curved lines for the top of the beak and two curved lines for the bottom of the beak. Draw a straight line from just below the eyes to the bottom of the beak.

3

I'm proud of you! Next draw a curved line for the head.

4

Draw a teardrop for the wing and two curved lines for the tail feathers.

5

Superb! Draw a long curved line for the stomach. For the legs, make two letter U's at the bottom of the stomach. Draw two straight lines under each letter U. Make zigzag lines for the parrot's zygodactyl toes.

6

To complete your cartoon parrot, add detail. Nice work on your parrot!

The Peacock

Peacocks are best known for their long, beautiful **trains** of metallic, blue-green feathers with spots that look like eyes. They also have bright blue feathers on their heads and bodies. "Peacock" is actually the name of the colorful male peafowl.

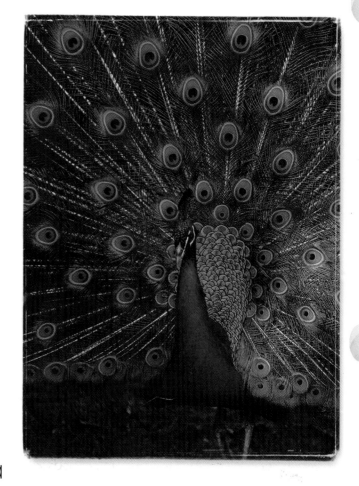

A female peafowl is called a peahen. When a peacock wants to show off for a peahen, he raises his colorful train and parades around. Peahens have brown, black, and white feathers and don't have trains. When peacocks **molt**, or shed their feathers, people often use the feathers to make jewelry and decorations. Most peacocks are native to the rain forests of India and Sri Lanka. They eat fruit, seeds, plants, insects, and small animals.

1

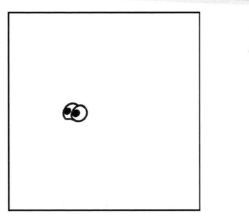

Start by making a circle with a curved line attached to the left side for the eyes. Add a small circle in each eye for the pupils. Shade in the pupils.

2

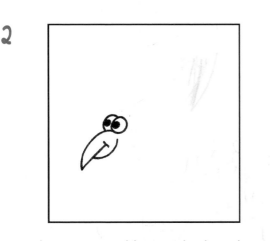

Next draw a curved line and a long letter *T* for the top of the beak and the mouth. Draw a short curved line for the bottom of the beak.

3

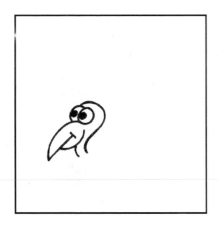

Marvelous! Draw a curved line for the top of the head and the back of the neck. Add a curved line for the front of the neck.

4

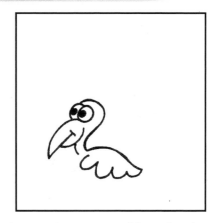

Next draw a long curved line for the top of the wing and four attached letter *U*'s for the bottom of the wing.

5

Super! Draw a curved line for the peacock's stomach. Add two letter *U*'s for the legs. Make two straight lines under each letter *U*. Draw zigzag lines for the peacock's feet.

6

Draw four straight lines on top of the peacock's head and add circles to their tips. Make the train with straight lines, zigzag lines, teardrops, and shaded circles. Beautiful!

The Owl

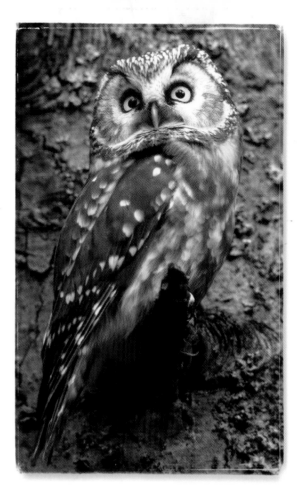

Owls are **birds of prey**. They are also **nocturnal carnivores**. Owls hunt at night for small animals like mice, rats, squirrels, and rabbits. They have very sharp hearing. On a dark, moonless night, owls can find their prey just by listening. The round, flat shape of an owl's face and its special feathers help the owl hear soft sounds. Owls also have excellent eyesight. Great gray owls can spot mice from 600 feet (183 m) away! Owls' eyes face forward and have feathers all around them. Owls cannot move their eyes, so they have to turn their entire heads to look around. Their feathers are so fluffy that owls don't make a sound when they fly. Owls live all around the world. They make their homes in treetops, cacti, holes in rock cliffs, and nests left by other birds. Some owls even dig underground nests!

1

Start by drawing two circles for the eyes. Draw a small circle in each eye for the pupils. Shade in the pupils.

2

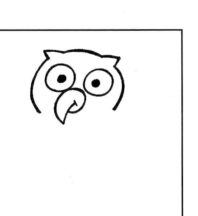

Next draw a long curved line for the beak. Add a small, curved letter *T* for the bottom of the beak and the mouth.

3

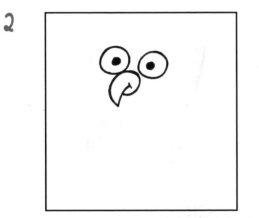

Nice work! Draw a curved line for the top of the head. Add zigzag lines on the left and the right sides of the curved line. Draw another curved line on the left and one on the right to complete the owl's head.

4

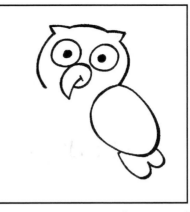

Next draw a teardrop with a rounded tip for the wing and two curved lines for the tail feathers.

5

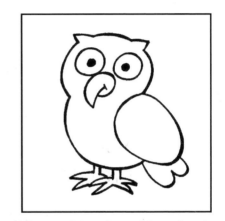

You did it! Add a curved line for the stomach. Make two straight lines for the legs and zigzag lines for the owl's feet.

6

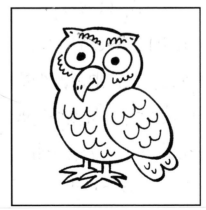

Add detail and wiggly lines for feathers to complete your owl. Great job!

11

The Penguin

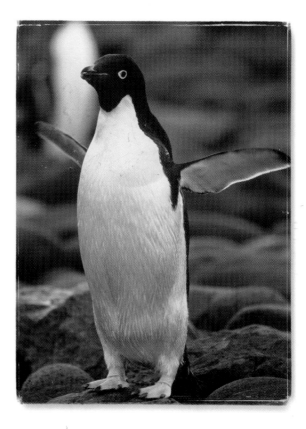

Penguins are flightless birds, but they are excellent swimmers. Gentoo penguins are the fastest swimmers, reaching underwater speeds of 17 miles per hour (27 km/h). Emperor penguins are the largest penguins. They can grow to almost 4 feet (1.2 m) tall and can weigh 65 pounds (29 kg). The little blue penguins of New Zealand and Australia are the smallest penguins. They stand from 12 to 16 inches (30–41 cm) tall and weigh about 2 pounds (1 kg). Penguins have short legs, flipperlike wings, webbed feet, and **waterproof** feathers. They eat sea animals, such as fish and **crustaceans**. Penguins dive deeper than do any other water birds. Emperor penguins can dive down to 1,500 feet (457 m). They can stay underwater for 18 minutes! Penguins live south of the equator. The largest groups live in **Antarctica**.

1

Start by drawing a circle. Add a curved line to its left side. Make a small circle in each eye for the pupils, and shade them in.

2

Next draw a zigzag line and a curved line for the beak. The curved line should touch the bottom of the eyes.

3

Great job! Draw a curved line for the head and the top of the wing. Make another curved line for the bottom of the wing.

4

Next draw a long curved line for the stomach. Add a short curved line and a zigzag line for the penguin's tail. Make two curved lines for the second wing.

5

Wonderful work! Draw two letter *U*'s at the bottom of the stomach for the legs. Add two straight lines under each *U*. Make the feet using short curved lines.

6

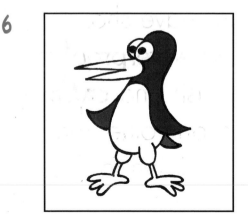

Add shading to the top half of your penguin to complete this cartoon. You did a great job on your penguin!

The Flamingo

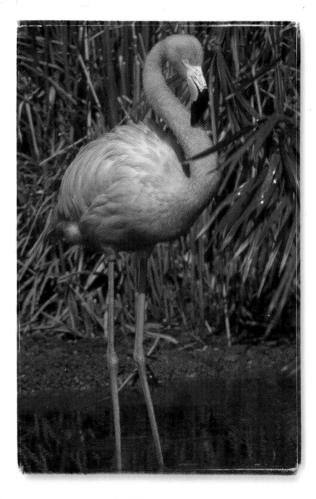

Flamingoes are pink birds with long, graceful legs. Some flamingoes grow to be 5 feet (1.5 m) tall! They live in **wetlands** and enjoy wading by the shore. They often gather in large flocks, but they don't like to get too close to one another. If one flamingo crowds another, the second flamingo may ruffle its feathers and honk until the first flamingo moves away. Flamingoes have long, **flexible** necks. Their necks make it easy for flamingoes to eat. They stick their heads under the water, upside down, facing backward. Then they open their bills to strain tiny plants, shrimp, and **nutrients** from the water. Flamingoes are born with gray feathers. Their feathers turn pink from all the shrimp they eat. Flamingoes also have a great sense of balance. They sleep standing on one leg!

1

Let's begin by drawing one circle for the left eye. Add a small circle inside the eye for the pupil, and shade it in.

2

Next draw a curved line and a long, curved letter *T* to make the top of the beak. Add a curved line for the bottom of the beak. Make another curved line for the other eye. Draw a small circle inside the eye for the pupil, and shade it in.

3

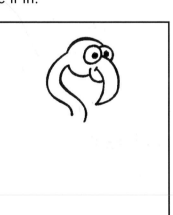

You did it! Add a curved line for the top of the head and one for the bottom of the head. Draw two curved lines, one for the front and one for the back of the flamingo's neck.

4

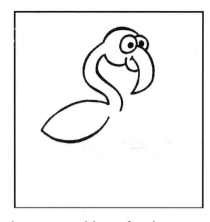

Next draw curved lines for the top and the bottom of the wing.

5

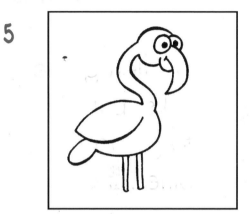

Beautiful work! Make a short curved line for the tail feathers and a long curved line for the flamingo's stomach. Draw two pairs of straight lines for the flamingo's legs.

6

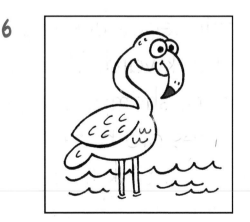

Add detail and shading to your flamingo and wiggly lines for water. I like it!

The Duck

Ducks live in wetlands all around the world. They can be found everywhere except Antarctica. Male ducks are called drakes. Females are called hens or ducks, and the babies are called ducklings. A mother duck lays from 4 to 12 eggs in a nest that is hidden in bushes, in reeds, or in grass near the edge of the water. On land ducks walk with a waddle. In the water, their short legs and webbed feet make them good swimmers. Ducks make their feathers waterproof by rubbing them with oils made by a special body part just above their tails. Underneath a duck's top layer of feathers are soft feathers called **down**. Down keeps ducks warm and helps them to float. Ducks eat plants, seeds, insects, worms, and snails. In the winter, many ducks **migrate** to warmer areas and then return to their nesting places in the spring.

1

Draw a circle attached to a curved line for the eyes. Make one smaller circle in each eye. Shade in the smaller circles.

2

Next draw a long letter *U* for the top of the beak and a curved line for the bottom of the beak. Add a short straight line to complete your beak.

3

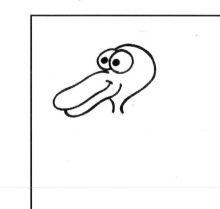

Wonderful! Draw a curved line for the head and the back of the neck and a short curved line for the front of the neck.

4

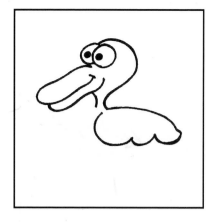

Next draw a long curved line for the top of the duck's wing and three curved lines for the bottom of the wing.

5

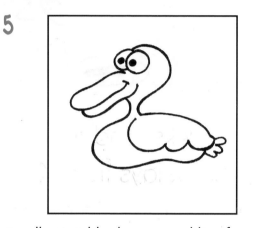

Excellent! Add a long curved line from the duck's neck to the back of the wing for the stomach. Make three short curved lines for the duck's tail.

6

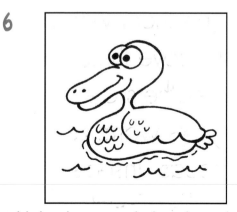

Add detail on your duck and wiggly lines for the water. You did a fantastic job!

The Chicken

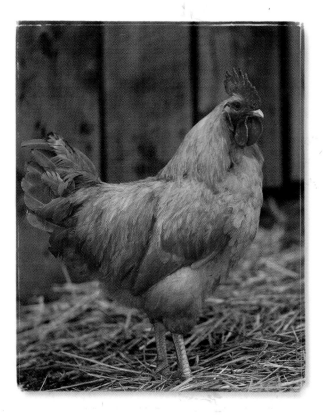

The chicken is a **domestic** bird that can be found on many farms. Its eggs and meat are important sources of food for people. Male chickens, called roosters, do not lay eggs. They have long, brightly colored feathers, red **combs** on their heads, and red **wattles** under their beaks. Roosters can be heard calling "cockle-doodle-doo" early in the morning. Roosters call at dawn when they hear other birds start chirping. Female chickens are called hens. Their combs and wattles are smaller than the roosters'. Hens lay eggs that are white or light brown. Baby chickens are called chicks. Chicks, like all birds, hatch from eggs. One hen can lay up to 280 eggs in a year. Around the world, hens lay about 600 billion eggs every year!

1

Make a circle with a curved line attached to its left side for the eyes. Draw a small circle in each eye for the pupils. Shade in the pupils.

2

Starting under the eyes, draw a curved line and a long letter *T* for the top of the beak. Add a curved line for the bottom of the beak. Make three curved lines for the wattle.

3

Super work! Draw five curved lines on the head for a comb. Make a short curved line for the front of the neck and a long curved line for the back of the neck.

4

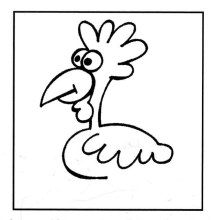

Next draw a long curved line for the top of the wing and five short curved lines for the bottom of the wing. Make a letter *C* for the stomach.

5

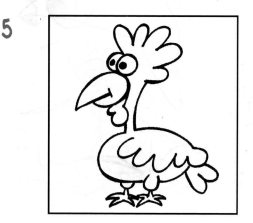

Beautiful! Draw two letter *U*'s for the tops of the legs. Add a short curved line. Add two more curved lines for the tail feathers. Make two straight lines under each *U* and zigzag lines for the feet.

6

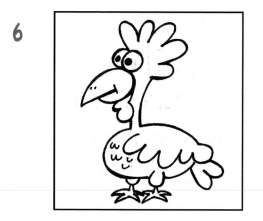

Add detail to the cartoon. You did splendid work on your chicken!

The Toucan

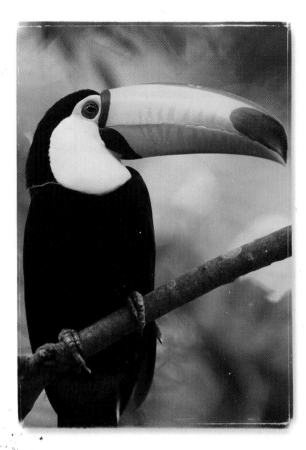

Toucans are known for their large, colorful bills and their brightly colored feathers. The bill of a toco toucan is more than 8 inches (20 cm) long! A toucan's bill looks heavy, but it is really very light because of its **air pockets**. The bill's colors may help a toucan to attract mates. Toucans that are getting ready to mate sometimes throw berries to each other with their bills! The bill and the **plumage** of a toucan can be red, blue, black, yellow, white, green, brown, or a mixture of these colors. These bright colors help toucans of the same species to recognize one another. Toucans live in rain forests, where they eat mostly fruits, nuts, and berries. Sometimes toucans will also eat insects, lizards, and other birds' eggs. Like their relative the woodpecker, toucans live in nests in tree holes.

1

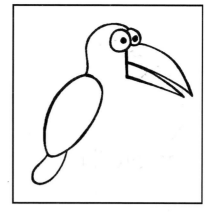

First make a circle for an eye. Add a curved line to its side for the other eye. Draw a small circle inside each eye for the pupils. Shade in the small circles.

2

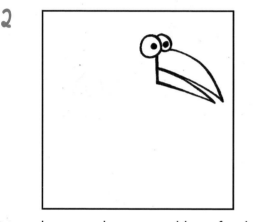

Next draw two long curved lines for the top of the beak and two long curved lines for the bottom of the beak. Draw a straight line from the bottom of the beak to the top of the beak, just below the eyes.

3

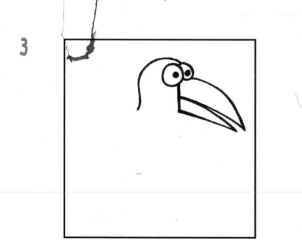

Great work! Add a curved line for the head.

4

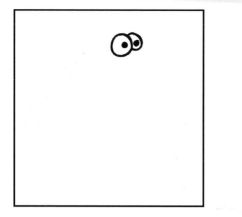

Next draw a teardrop for the wing and a curved line for the tail feathers.

5

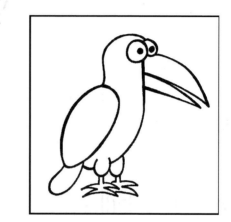

Excellent! Draw a long curved line for the stomach. Draw a short curved line near the tail, then two letter U's for the legs. Draw two straight lines under each U. Make zigzag lines for the toucan's feet.

6

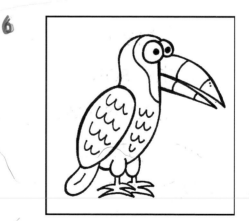

Add detail for the feathers and stripes on the bill. I'm proud of your work!

Terms for Drawing Cartoons

Here are some of the words and shapes that you need to know to draw cartoon birds:

O	Circle
⌒	Curved line
Ɛ∴ʊʊ	Detail
C	Letter C
U	Letter U
T	Letter T
⌁	Shade
I	Straight line
◊	Teardrop
≈≈≈	Wiggly lines
⋜	Zigzag lines

Glossary

air pockets (AIR PAH-kits) Small areas where air is trapped.

Antarctica (ant-ARK-tih-kuh) The icy land at the southern end of Earth.

birds of prey (BERDZ UV PRAY) Birds that hunt, kill, and eat animals.

camouflage (KA-muh-flaj) The color or pattern of an animal's feathers, fur, or skin, which helps it blend into its surroundings.

carnivores (KAR-nih-vorz) Animals that eat other animals.

combs (KOHMZ) Soft pieces of pointed skin on top of chickens' heads.

crustaceans (krus-TAY-shunz) Sea animals with hard outer shells. Lobsters, shrimp, and crabs are crustaceans.

domestic (deh-MES-tik) Tamed and cared for by humans.

down (DOWN) The soft, light feathers underneath a bird's top feathers.

editorial (eh-dih-TOR-ee-uhl) A written or drawn work that shows the views of the person who made it.

environments (en-VY-urn-ments) The weather and living things that are part of different areas.

flexible (FLEK-sih-bul) Easily bent in different directions.

flightless (FLYT-les) Not able to fly.

migrate (MY-grayt) To move a long distance from one place to another.

molt (MOHLT) To shed, or lose, feathers or outer skin.

New World (NOO WURLD) North America and South America.

nocturnal (nok-TER-nul) To be awake and active during the night.

nutrients (NOO-tree-ints) Parts of food that give nourishment or nutrition.

plumage (PLOO-mij) The feathers of a bird.

predators (PREH-duh-terz) Animals that hunt other animals for food.

trains (TRAYNZ) Long feathers that trail behind birds.

tropics (TRAH-piks) The warm parts of Earth that are near the equator.

tundra (TUHN-druh) A frozen area with no trees and with black soil.

waterproof (WAH-ter-proof) Not able to get wet.

wattles (WAH-tuhlz) Soft growths of skin under a bird's beak.

wetlands (WET-lands) Land with a lot of moisture in the soil.

zygodactyl toes (zy-guh-DAK-tuhl TOHZ) Two toes that point forward and two toes that point backward.

Index

Web Sites

To learn more about birds, check out these Web sites:

http://birds.cornell.edu/bow/

http://www.petplanet.com